ACRYLIC
M A D E
A S Y

PORTRAITS

Date: 5/20/20

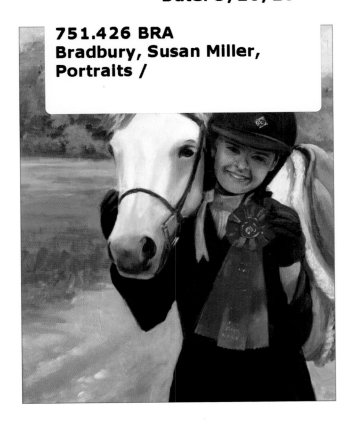

Susan Miller Bradbury

**PALM BEACH COUNTY
LIBRARY SYSTEM
3650 Summit Boulevard
West Palm Beach, FL 33406-4198**

www.walterfoster.com

Publisher: Rebecca J. Razo
Art Director: Shelley Baugh
Project Editor: Jenna Winterberg
Senior Editor: Stephanie Meissner
Managing Editor: Karen Julian
Associate Editor: Jennifer Gaudet
Assistant Editor: Janessa Osle
Production Designers: Debbie Aiken, Amanda Tannen
Production Manager: Nicole Szawlowski
Production Coordinator: Lawrence Marquez

Walter Foster

www.walterfoster.com
6 Orchard Road, Suite 100
Lake Forest, CA 92630

Printed in USA
3 5 7 9 10 8 6 4

CONTENTS

INTRODUCTION

I have been passionate about art my entire life. My mother was my gateway. Even as a young child, I can remember happily watching her as she'd draw and paint. Later, I'd try to imitate and replicate her work.

Despite many years of dedication to the craft, I am still working hard to grow and improve as an artist. I'm always correcting and refining, learning from my own successes—and yes, even my mistakes. I also take classes so that I can learn from other artists and their unique experiences.

As a beginning artist, I encourage you to embrace opportunities to learn. Start by re-creating the step-by-step paintings I've laid out for you in this book. Approaching a painting becomes much less intimidating when you break it down by layers, colors, and techniques.

The more you practice, the less thinking you will have to do, which allows you to focus on the emotion of the painting. To me, feeling and emotion are the two most important aspects of the painting process. I express myself through painting in a way I can't with words. My portraits capture emotion and feeling in the subjects and speak for them just as clearly as words. With a little practice, you too can master this art!

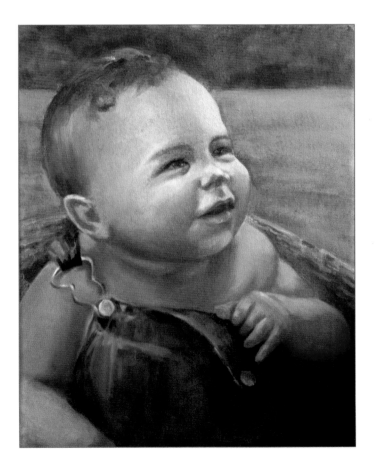

TOOLS & MATERIALS

To get started with acrylic, you need only a few basic tools. When you buy supplies, try to buy the best quality you can afford. Better-quality materials are both more manageable and longer lasting.

Workspace

Having a space dedicated to making artwork is great, but you don't have to have your own studio to be a successful painter. You simply need a clean area with good lighting where you can keep your supplies organized and within reach.

I use a standing French easel with a clamp at the top, but work with any easel that is comfortable, as long as it can tilt back at an angle. I also have a large table handy for techniques that require me to spread out my materials. You'll notice my taboret table has wheels; anything portable with drawers will do to keep your materials contained and easy to find.

I prefer natural lighting, so I work with a big open window with soft, northern light. But artificial lighting is always an option (and a good backup for bad-weather days). I recommend finding bulbs that have been rated for color temperature; 5,000 Kelvin will provide a good white light for your work.

I try to keep distractions to a minimum in my workspace. As a lefty, I keep the majority of my materials to the left of my easel, which keeps me from knocking things over!

Palette

A variety of acrylic palette styles are available, but I prefer the stay-wet palette. It has a foam pad that keeps the palette wet and your paints moist, which is very important with acrylic. Most versions come with a lid, which will seal the palette and prevent the paint from drying when it's set aside for up to a few days. At times, I'll use paper palettes and keep a spray bottle on hand to moisten the paints.

▶ With a stay-wet palette, you moisten the underlying foam before applying paint.

Brushes

I prefer soft, synthetic bristle brushes for the watercolor effect they produce and because they are easier to clean. They also tend to be less expensive. When I need to drybrush or add texture, I sometimes use a stiffer hog-hair bristle brush instead. I keep several shapes on hand:

Flat

Flat brushes are easy to load with large quantities of paint, so I like them for placing washes and filling in large areas of color with thick paint. You can also paint more tightly with their sharp edge.

Filbert

Filbert brushes soften the appearance of strokes because of their flat-meets-oval shape, which also makes them good for blending.

Bright

Bright brushes are easier to control, making them ideal for close-up work and detail.

Round

Round brushes come to a tapered tip, making them ideal for drawing with paint.

I always rinse the brush between each application of paint, as acrylics dry very quickly. When I finish for the day, I clean the brushes thoroughly with a brush cleaner, massaging into the ferrule and hair of the brush and then rinsing.

Painting Surfaces

I use a wide variety of painting surfaces, depending on the texture and effect I want to achieve: hard, flat, pre-gessoed panels; flexible, pre-gessoed linen canvases; plain canvas; smooth woods; or even old discarded cabinet doors! Experiment with whatever you can get your hands on to see the effects firsthand, and then choose your personal favorites. The only rule is to be sure that your surface is free of any oil-based medium, which will cause your acrylic paints to peel.

Paints

I always use professional-grade paints. Inexpensive, student-grade paints seem like a deal, but they don't have as much pigment (instead, they contain more binder); you'll end up using more paint to achieve the same results, so the cost evens out. I have a few brands I use time and time again; you'll develop your own favorites as you experiment with what's on the market. Paints also come in a variety of consistencies. I prefer heavy-body paint for thick, rich cover. Soft-body paint produces smooth, creamy results and can also be thinned easily for transparent washes. Inks are nice for washes, as well as fine details.

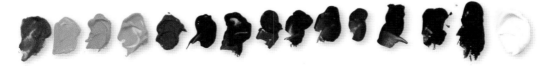

My usual palette (from left to right): yellow ochre, cadmium yellow light, cadmium yellow deep, brilliant yellow green, chromium green oxide, Prussian blue, ultramarine blue, cobalt blue, quinacridone blue violet, alizarin crimson, quinacridone magenta, transparent red iron oxide, burnt umber, raw umber, and titanium white. I sometimes add cadmium red medium, cadmium red light, green gold, lemon yellow, Hansa yellow, yellow iron oxide, Indian yellow, and manganese blue (not pictured).

Additional Supplies

I like to keep some additional basic supplies on hand while I paint. Paper towels are useful to clean and dry brushes. A spray bottle keeps paints moist and also helps wet the surface for washes. A jar for water to rinse brushes is an absolute necessity. I keep a plastic card, such as an old credit card, handy to scrape paint and gesso. I also like to use a variety of gel mediums to create texture and glazes. Gels can create unique textures, as well as protect your paints from ultraviolet light.

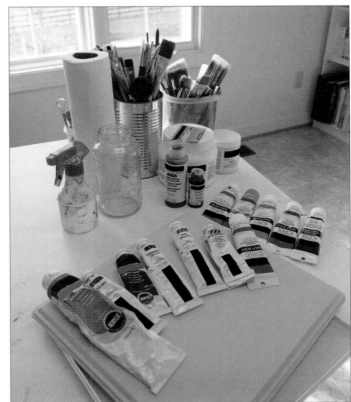

My additional supplies, from gels to jars, are painting necessities rather than extras.

ACRYLIC TECHNIQUES

There are myriad techniques and tools that can be used to create a variety of textures and effects. By employing some of these different techniques, you can spice up your art and keep the painting process fresh, exciting, and fun!

Flat Wash This thin mixture of acrylic paint has been diluted with water. Lightly sweep overlapping, horizontal strokes across the support.

Graded Wash Add more water and less pigment as you work your way down. Graded washes are great for creating interesting backgrounds.

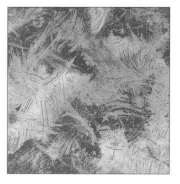

Drybrush Load a worn flat brush with thick paint, wipe it on a paper towel to remove moisture, and apply it to the surface with quick, light, irregular strokes.

Impasto Thick, undiluted acrylic can mimic the effects of oil paints. When the paint is layered on in this manner with a paintbrush or a palette knife, the result is opaque and textured.

Lifting Out Use a moistened brush or a tissue to press down on a support and lift colors out of a wet wash. If the wash is dry, wet the desired area and lift out with a paper towel.

Wet-into-Wet Apply a color next to another that is still wet. Blend the colors by stroking them together where they meet, and use your brush to soften the edges to produce smooth transitions.

Applied Techniques

Below you'll see my approach to special techniques for use in portraiture.

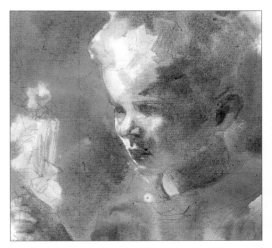

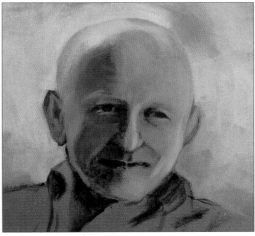

Wet-into-Wet Washes When you wet the canvas before applying a wash, the loose blend of colors produces a dynamic watercolor effect. To set the soft tone of this painting, I wet the surface in the underpainting before pouring thinned paint mixes directly on the canvas and using a wide, flat brush to guide the flow of the paint.

Scumbling This thick painting technique is one way to apply a thick layer of opaque paint. In this case, the paint is thinned with a little water and brushed lightly over another layer so that patches of the underlayer still show through. Scumbling allows me to layer light-colored paint to create a highlight without unwanted texture.

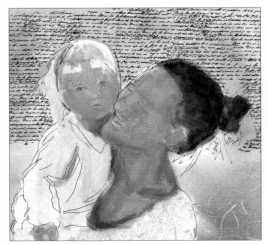

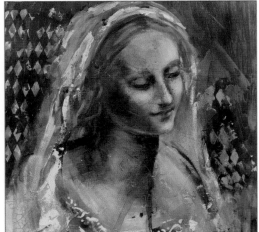

Gel Mediums Sometimes I layer on gel mediums to give my paintings a textured appearance or to seal a completed painting. Other times, I use them to lighten the overall color of a piece. In this instance, gel medium allowed me to layer specialty papers onto my painting, creating a mixed-media presence.

Texture Mediums Texture mediums are specifically designed to produce texture, whether from the gel itself or impressions of a tool. In this example, I smoothed spackling compound over a template for the background diamond shapes. I also applied crackle paste in areas to produce an aged appearance.

COLOR BASICS

Before you begin painting, it's important to know basic color theory. Color plays a huge role in the overall mood or "feel" of a painting, as colors and combinations of colors have the power to elicit various emotions from the viewer. On these pages, you'll learn some basic color terms. You'll also discover how colors affect one another, which will help you make successful color choices in your own paintings.

Learning the Basics

The color wheel is a circular spectrum of colors that demonstrates color relationships. Yellow, red, and blue are the three main colors of the wheel; called *primary* colors, they are the basis for all other colors on the wheel. When two primary colors are combined, they produce a *secondary* color (green, orange, or purple). And when a secondary and primary color are mixed, they produce a *tertiary* color (such as blue-green or red-orange). Colors that lie directly opposite one another on the wheel are called "complements," and groups of colors that are adjacent on the color wheel are referred to as "analogous."

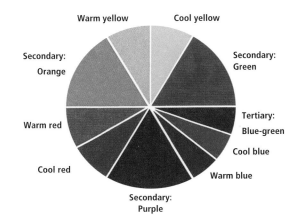

The Color Wheel This handy color reference makes it easy to spot complementary and analogous colors, making it a useful visual aid when creating color schemes.

Exploring Color "Temperature"

The colors on the color wheel are divided into two categories: *warm* (reds, oranges, and yellows) and *cool* (blues, greens, and purples). Warm colors tend to pop forward in a painting, making them good for rendering objects in the foreground; cool colors tend to recede, making them best for distant objects. Warm colors convey excitement and energy, and cool colors are considered soothing and calm. Color temperature also communicates time of day or season: warm corresponds with afternoons and summer, and cool conveys winter and early mornings.

Seeing the Difference in Temperature Above are two similar scenes—one painted with a warm palette (left), and one painted with a cool palette (right). The subtle difference in temperature changes the mood: The scene at left is lively and upbeat; at right, the mood is peaceful.

Using Color Complements

Selecting your palette based on a pair of complementary colors can add a vibrancy to a painting that's difficult to attain with other color combinations. When placed next to each other, complementary colors (such as green and red) make one another appear brighter and dynamic because they seem to vibrate visually.

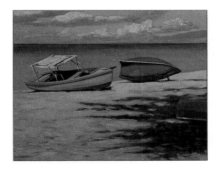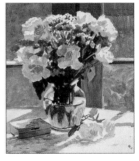

Applying Complementary Color Schemes The paintings above demonstrate two different complementary color schemes. The boat image (left) utilizes a blue and orange scheme that makes the sand appear to glow beneath the sun. The flowers image (right) has a yellow and purple color scheme, causing the flowers to radiate with intensity—even in the soft light from the window.

Mixing Neutrals

Neutral colors (browns and grays) are formed by mixing two complementary colors or by mixing the three primaries together. By altering the quantity of each color in your mix or by using different shades of primaries, you can create a wide range of neutrals for your palette. These slightly muted colors are more subtle than those straight from the tube, making them closer to natural colors. Below are a few possibilities for neutral mixes using the colors of a basic palette.

Prussian blue + alizarin crimson + Naples yellow

Phthalo blue + cadmium red light + cadmium yellow light

Light blue-violet + burnt sienna + yellow ochre

Understanding Value

Value is the lightness or darkness of a color or of black, and values are used to create the illusion of depth and form in two-dimensional artwork. With acrylic paints, artists generally lighten paint mixes with lighter paint, such as white or cadmium yellow. However, acrylic can also be applied in thin washes like watercolor, in which case the white of the paper beneath the paint acts as the lightener. Creating a value scale like the one below will help you determine how the lightness or darkness of a color is altered by the amount of water added.

Value Scale Creating value scales like the ones above will help you get a feel for the range of lights and darks you can create with washes of color. Apply pure pigment at the left; then gradually add more water for successively lighter values.

MIXING SKIN TONES

There is no one formula for matching a skin tone—after all, skin colors are as varied as personalities! But you can approach your subject with the colors that will be present in mind, just in unique proportions that reflect the individual and his or her particular complexion. Note that I layer skin tones, applying many applications to achieve a natural appearance. The midtone is the mix of base colors, with highlights and shadows complementing it. Here, I've simply broken down those three categories into their common base values.

Caucasian and Light Skin Tones

With light skin tones, I use white generously in the lightest values; I also include cadmium red medium to give the tone warmth. For cooler, pinker values in the midtones, I mix alizarin crimson and raw sienna first. Shadows are always more muted, so manganese blue serves to neutralize and cool.

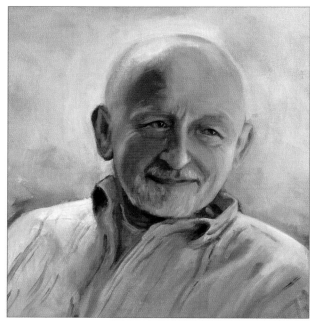

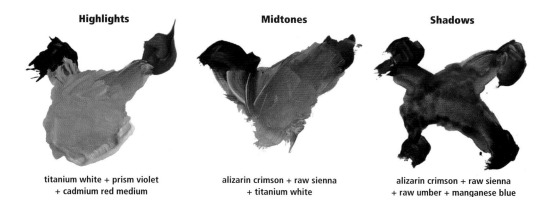

Highlights	Midtones	Shadows
titanium white + prism violet + cadmium red medium	alizarin crimson + raw sienna + titanium white	alizarin crimson + raw sienna + raw umber + manganese blue

Asian, Middle-Eastern, and Related Skin Tones

With skin that has a yellow undertone, it's important to include warmth to prevent the subject from looking sickly. For my lightest tones, I include yellow ochre but also alizarin crimson. Likewise, in my midtones, yellow ochre is present, but muted by quinacridone magenta. I apply multiple light washes to naturally build up color in layers. The darkest shadows, neutralized with a touch of phthalo blue, also require thin applications to build up the value.

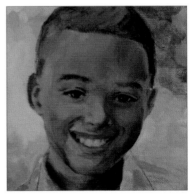

Highlights

titanium white
+ yellow ochre
+ alizarin crimson

Midtones

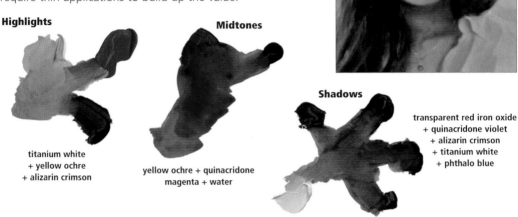

yellow ochre + quinacridone
magenta + water

Shadows

transparent red iron oxide
+ quinacridone violet
+ alizarin crimson
+ titanium white
+ phthalo blue

African-American and Other Darker Tones

Even the deepest of skin tones require a large quantity of white for the highlights. For the depth of tone demonstrated here, I also include quinacridone blue violet, which provides a cooler tone. The midtones reflect that same cool blue for depth, but are balanced with transparent red iron oxide to provide warmth and life to the skin. I want that same richness in the shadows, where the blue tone becomes even cooler with the addition of Prussian blue, but the warm of the transparent red iron oxide remains in play.

Highlights

titanium white
+ transparent red iron oxide
+ quinacridone blue violet

Midtones

quinacridone blue violet
+ transparent red iron oxide

Shadows

Prussian blue
+ transparent red iron oxide

PLANES OF THE HEAD

It's helpful to approach the head with a general idea of what can be expected. With practice, you will automatically check for the basic forms and plane changes described below. Memorizing the planes early on will save you time.

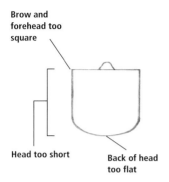

Brow and forehead too square

Head too short

Back of head too flat

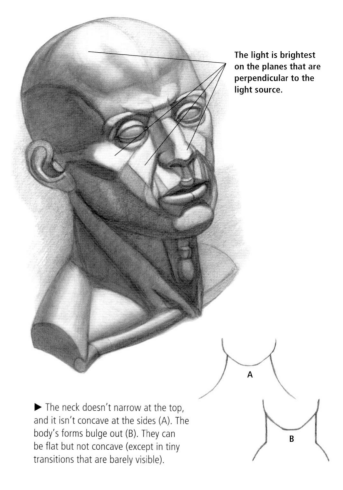

The light is brightest on the planes that are perpendicular to the light source.

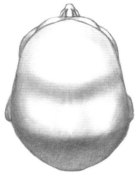

▲ Artists unfamiliar with the top view of the head make errors at the brow, with the shape of the forehead, and in the head's overall length and width.

▶ The neck doesn't narrow at the top, and it isn't concave at the sides (A). The body's forms bulge out (B). They can be flat but not concave (except in tiny transitions that are barely visible).

A

B

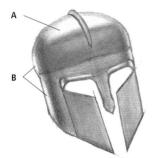

A

B

The face wedges toward the nose like this helmet. Notice the exaggerated highlights (A) and reflected light (B) on the metal.

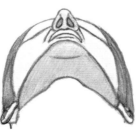

This illustration of a Caucasian male shows how the face wedges toward the center.

This illustration of an Asian male shows a flatter face and sharper angles at the sides of the head.

GENERAL PROPORTIONS

Proportion (the comparative sizes and placement of parts to one another) is key to creating a like-ness in portraits. Although proportions vary among individuals, there are general guidelines to remember that will help you stay on track. Before you study the diagrams and tips below, memo-rize these two most important guidelines:

1. The face is usually divided into thirds: one-third from the chin to the base of the nose, one-third from the nose to the browridge, and one-third from the browridge to the hairline.
2. The midpoint of the head from the crown to the chin aligns with the tear ducts.

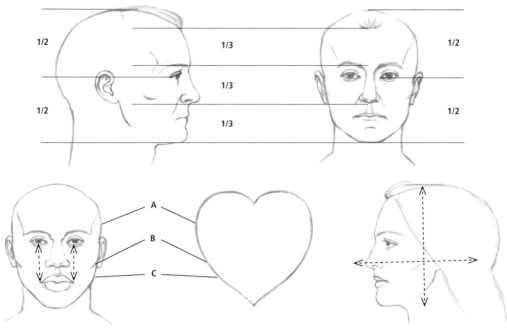

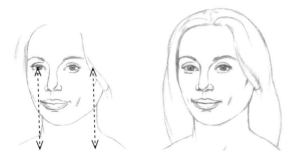

The mouth is usually the same width as the distance between the pupils. This particular model's tear ducts are higher than the midpoint.

Heads are somewhat heart shaped. The temple (A) is wider than the cheekbone (B), which is wider than the jawline (C).

Generally, the distance between the tip of the nose and back of the head is longer than the distance from the top of the head to the bottom of the head.

To determine the width of the neck, use the features directly above each side of the neck to serve as a guides for placement. To easily see this, hold up a pencil vertically in front of you, lining it up with the side of the model's neck.

PROPORTION SUBTLETIES

- The neck pitches forward slightly.
- The neck doesn't narrow as it goes up to the jaw.
- You can usually fit another eye between the eyes.
- If you've diligently measured and the model's face is asymmetrical or involves different proportions than these, that's okay. These are guidelines—not strict rules.

APPROACHING FACIAL FEATURES

The nuances of our facial features—their shape, size, and even proportions—give each of us our unique appearance. Because there is such a variation from person to person, there are no set guidelines for how to paint an eye, a nose, or a pair of lips. But the approach you take for sketching the shape, developing the form, and making the feature seem real remains the same, no matter the unique trait you encounter.

Working from a Photo When painting your first portraits, you may find it easier to work from a photograph rather than life. Still features are certainly easier to capture than moving ones that are busy expressing themselves! A photograph has another advantage: You can turn it upside down. Sometimes we expect to see certain shapes, and our sketch reflects that. By turning your perspective on its head, you can focus on the lines and shapes you actually see, rather than what you anticipate to be there.

The Eye

Step 1 We all know what an eye looks like, right? Think again. Before you begin your sketch, take a closer look. Have you ever noticed the folds in the skin around the eye? The way the eyeball lays in the socket? Think about the underlying bone structure and how it affects the shape and form. Now, sketch what you see. Be sure to place the pupil in the center of the iris.

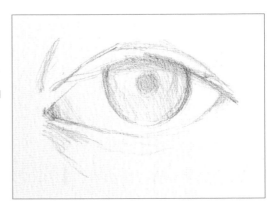

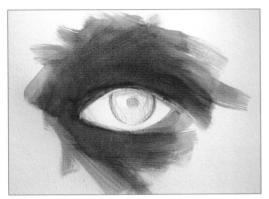

Step 2 The first thing I do once I'm happy with my sketch is lay in the local skin color around the eye. Note the way that my brushstrokes follow the eye's orbit. Moreover, the area closest to the eye sinks a bit lower, making it more shadowed. This attention to detail will give form and shape to the eye.

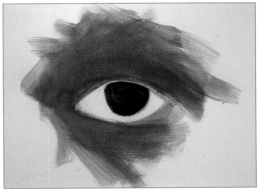

Step 3 Next I lay in the base color of the iris. To make sure the intensity of the color is appropriate, I neutralize the blue with a complementary color. Here that combination is ultramarine blue with a bit of burnt umber. For the pupil, I use the same mix, but add more burnt umber for a darker value.

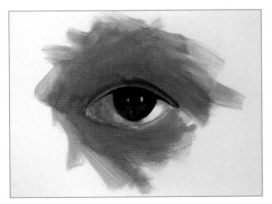

Step 4 The iris is a bit darker in color around the rim. I use my pupil color to lightly touch in the dark blue-gray around the iris. For highlights, I lighten the iris mix with a little white. I also block in the whites of the eyes, graying white with a hint of raw umber. Pure white would look unnatural. For the upper lid crease, I lightly brush on a mix of ultramarine blue, transparent red iron oxide, and quinacridone blue violet. I darken the eyeline with raw umber and a touch of ultramarine blue.

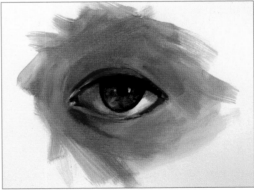

Step 5 In the final stage, I add more highlights—this time to the iris itself, lightening the area that is not in the lid's shadow. To add realism, I also mix a touch of cadmium red medium with raw umber to line the inner rim of the lower eyelid. I revisit the skin around the eye to finish the shape and form, brushing on the dark shadow of the undereye as well as final highlights.

The Nose

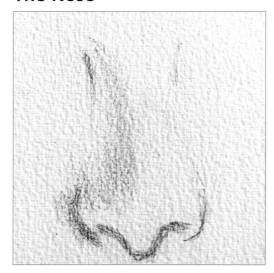

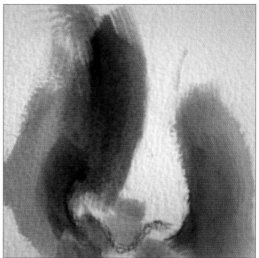

Step 1 When sketching the nose, note the angles of the sides of the nose and the shape and flare of the nostrils. Avoid giving the entire shape a hard outline. The nose stands out from the rest of the face, but it isn't separated. Lines should indicate the areas of deepest shadow; shadowing with paint will accomplish the rest in a more natural way.

Step 2 I start by applying the deepest values. For this skin tone, I've mixed transparent red iron oxide with quinacridone blue violet, brushing it along the bridge of the nose before adding a touch of ultramarine blue for the cooler shadows beside it. I use a light application of this deeper color to indicate the creases of the nostrils and eye socket.

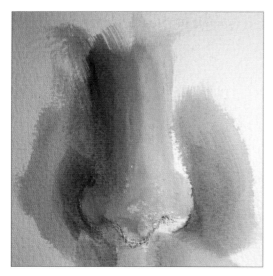

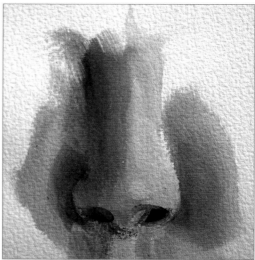

Step 3 With the dark values placed, I return to place my mid-tones. These applications will require more warmth so that they appear to come forward. That's what provides the shape and form of the nose. For this skin tone, I mix titanium white with a trace of cadmium red light and quinacridone blue violet to achieve that effect, varying the proportion of white depending on the placement of the color.

Step 4 I save the lightest and darkest tones for last. First I scumble on even lighter highlights, mostly white. These are limited to the most prominent parts of the nose: along the bridge, at the tip, and along the nostril's flare. The nostrils are the darkest tone. Although they are deep in shadow, black would be too severe. Instead I use a touch of raw umber for a more natural shadow.

The Mouth

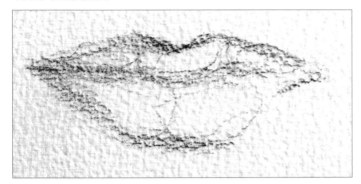

Step 1 I draw the lips roughly before painting them. Instead of an outline, I actually begin by overlapping a series of ovals to make sense of the lips' shape and volume.

Step 2 The lips are the simplest feature to paint: I just add a little red to the main skin tone, darkening the corners of the mouth slightly to produce the illusion of dimension. I start with a slightly darker value of transparent red iron oxide, quinacridone blue violet, and titanium white, which I apply to the upper lip, pushing it into shadow. For the lower lip, I add a touch of cadmium red medium and more white for the pout.

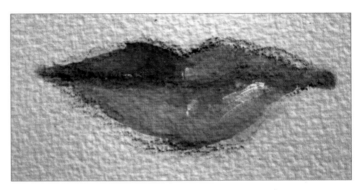

The Ear

Step 1 Similar to the nose, I don't want a lot of hard lines in my initial sketch. Instead I'll use shadows to create dimension and suggest depth.

Step 2 I start with a light underpainting of raw sienna. Then I build up midtones with a mix of transparent red iron oxide and quinacridone blue violet. For the darkest shadows, I use a mix of dioxazine purple, transparent red iron oxide, and Prussian blue.

PAINTING WET-INTO-WET

Children never seem to stop—moving, learning, growing, changing. A portrait is a wonderful opportunity to press pause, stopping time to capture a child in one moment. Rather than ask a child to sit still, I prefer to take photographs as a child interacts with the world, providing a stop-motion reference from which I can work.

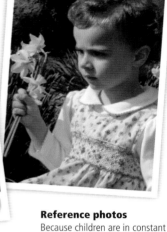

Palette

cadmium red medium • cadmium yellow medium • green gold lemon yellow • phthalo blue phthalo green • quinacridone magenta • titanium white transparent red iron oxide (TRIO) ultramarine blue

Reference photos
Because children are in constant motion, getting the perfect shot for a portrait can prove challenging. Thankfully, it's easy to combine references—using a pose from one photo and an expression from another, for example, as I decided to do here—for a portrait-worthy result.

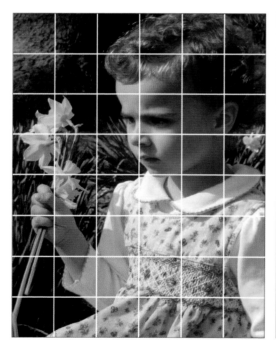

Grid Method If drawing intimidates you, an easy way to approach sketching a subject is by transferring a photo to your canvas using the grid method. Simply divide your reference and canvas into an even number of squares, and then draw what you see in each square on your canvas. These small parts are more manageable than a whole subject.

Step 1 Ideally you should transfer your drawing to a proportional canvas so that your grid squares translate exactly. Here I transferred a 4" x 6" photo to a 14" x 18" canvas, so I allowed an extra inch on each side to account for the difference. After transferring, I check my work as a whole, refining the lines of my sketch as needed.

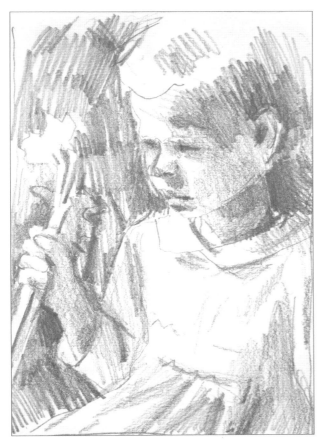

Value Sketch Before I begin applying color, I make a quick thumbnail sketch to work out the value scale of my painting. This prepares me to both mix and apply the correct values, and it also will assist me in correcting any compositional problems that might arise while I work.

WET-INTO-WET PREPARATION

The soft, feminine colors of this piece and its delicate subject are a good match for water-color techniques. I decide to start with a wet-into-wet tech-nique for the underpainting to establish tone. This technique can be messy, so I like to cover my work surface with a trash bag before misting the canvas with an even coat of water. Then I puddle water-thinned washes on my palette to pre-pare for application.

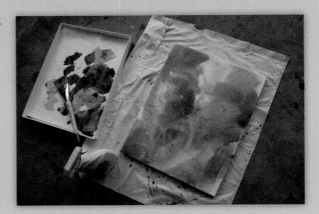

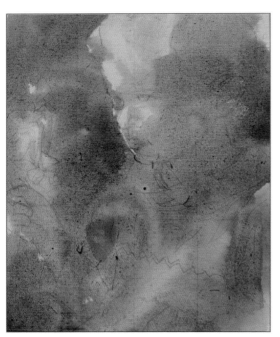

Step 2 I begin by dropping water-thinned paint onto the damp canvas (see "Wet-into-Wet Preparation" on page 21). For the dark greens, I mix phthalo blue, phthalo green, and a touch of TRIO. For the dress and skin shadows, I use quinacridone magenta mixed with phthalo blue. For the lighter skin, I use a thin layer of TRIO. I let the colors merge, tilting the canvas for drip effects. Then I lift out the lightest values.

Step 3 To better define the skin values, I darken the shadows, including areas around the eyes, nose, cheek, chin, neck, and wrist. I apply a mixture of magenta and phthalo blue—both transparent pigments—to achieve a watercolor layering effect.

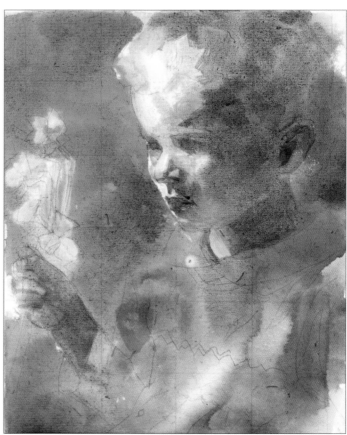

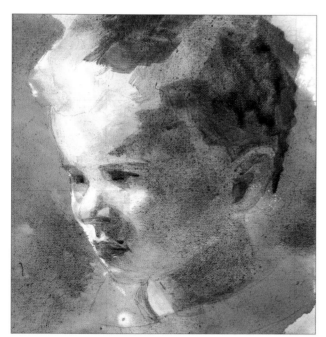

Step 4 Consulting my value sketch, I see that the deepest darks are at the back of the head, neck area, ear, nostril, and corner of the lips. To touch in these areas, I mix together quinacridone magenta and phthalo blue, adding a small amount of TRIO to lessen the intensity.

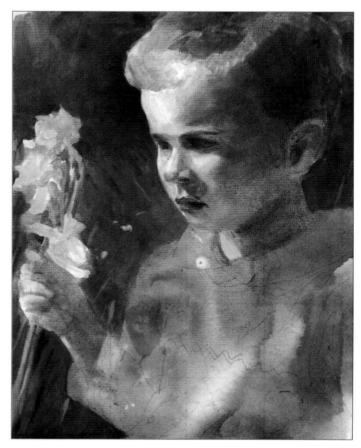

Step 5 My subject is not popping against the muted green background, so I increase the contrast by applying a cool mixture of phthalo green with a touch of TRIO to tone down the brightness. In addition to the value contrast this produces, the green will recede, as cool colors do, helping my warm subject stand out against a dark background.

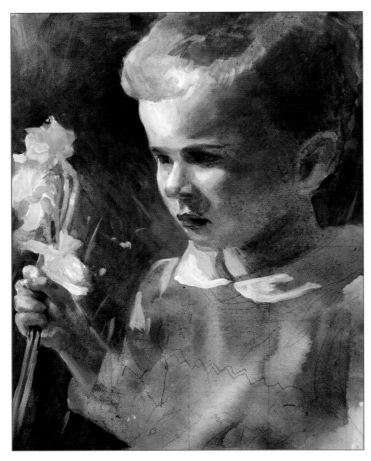

Step 6 I apply phthalo green, cadmium yellow, and a touch of white to the grass. I paint the daffodils lemon yellow, with white for highlights and green gold at the stems—a mix of phthalo green, green gold, and white. The underpainting creates some warmth, but I also apply a thin layer of white mixed with a touch of TRIO and magenta over the light skin tones to enhance the child's complexion. For reflections, I place a thin layer of cadmium red on the cheek and a mix of phthalo blue, magenta, and white on the forehead. I mute cadmium red with a touch of phthalo green for the lips, lightening from the center.

DETAILS

Hand To give the fingers dimension and make them appear as if they curve, I apply a cool, transparent glaze of phthalo blue to the curled fingers, which makes them appear to recede behind the warmer-toned parts of the hand.

Eyes For each eye, I add color to the lower edge of the iris with a thin wash of ultramarine blue and a touch of white, leaving the pupil and area underneath the eyelashes in shadow. I also add a touch of gray over the lens area, making it darkest under the eyelid and lightening as I move toward the lower lid.

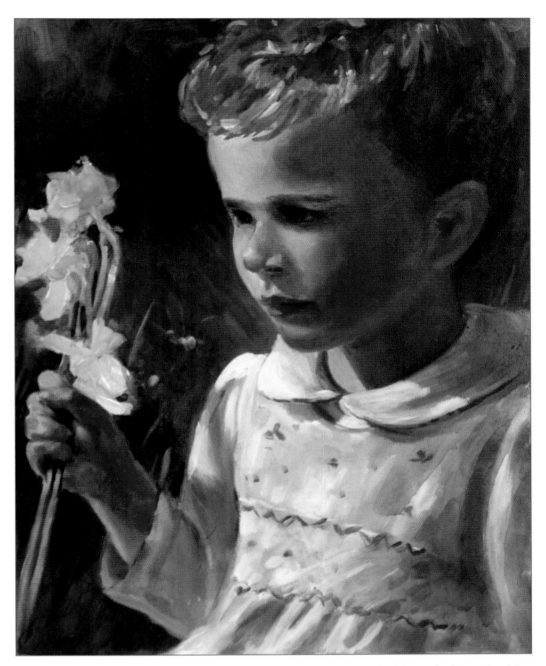

Step 7 The overall look of the skin tone is a little too cool, so I warm the highlight areas with a light mix of cadmium red, cadmium yellow, and white. I use the same mixture with more white to warm up the dress, scumbling the lightest areas with a somewhat dry brush. To prevent the dress from becoming the focal point, I use very light touches of color to indicate the pattern. For a finishing touch, I apply highlights to the hair, reflecting both cool sky and warm sunlight with a very light value of quinacridone magenta mixed with TRIO and phthalo blue.

CAPTURING PERSONALITY

A good portrait captures the essence of a person, letting personality shine and speak through the painting. Adults make this easy, expressing personality through choice of clothing and hairstyle. Young children don't make such decisions for themselves, yet reveal personality in other ways—especially through facial expression. Let your subject supply the personality, which you can complement with your choice of colors; then both you and your subject can express yourselves!

Palette

brilliant blue • brilliant yellow green • burnt umber
cadmium red • cadmium yellow light
chromium green oxide • green gold • Prussian blue
quinacridone blue violet • titanium white
transparent red iron oxide (TRIO) • ultramarine blue

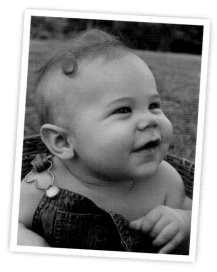

Reference photo Babies are not all alike—some are sweet, others shy, some observant. My subject for this painting is bubbly and vivacious, which comes across in both his expression and pose in the photo I selected. He has such a spark that I decide to manipulate the saturation of the picture before I paint for more brilliant colors to match his natural vibrancy.

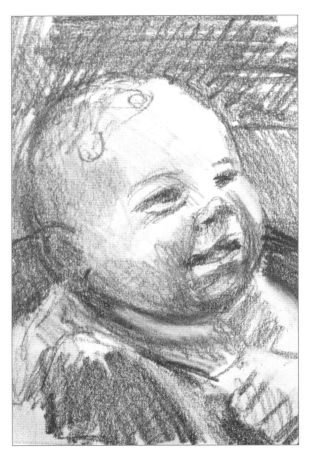

Value study Values are often easier to see in black and white, so I work out a quick thumbnail of my subject that will guide my use of color as I paint. The sketch also provides an opportunity to work out the model's likeness before I sketch the image on canvas.

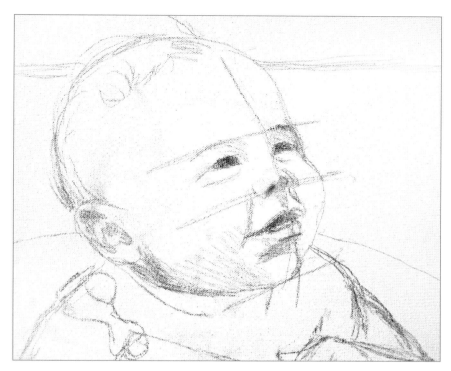

Step 1 I use many tricks for sketching accurately on canvas—one of them is to break up the face with a series of measurement lines, which help me position the features with correct proportions. I start with a baseline down the center of the face. From there I measure to the nostril's corner and the eye's inside corner. Next I gauge the eye's width. Meanwhile, horizontal guides help me establish the distance from the bottom of the nose to the center of the mouth, as well as the depth of eyebrow to eye.

PREVENTING SMUDGING

My sketch is an important guide, and I'd like to ensure it remains in place to guide me as I apply my layers of paint. So after I complete it, I use a fixative spray to keep the pencil lines from smudging. I like to lay the canvas on a piece of plastic or a trash bag outdoors and then spray the fixative until the canvas glistens. I allow this to dry completely before applying any paint or water to the canvas.

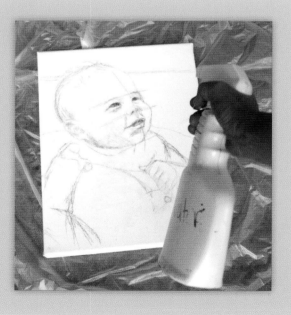

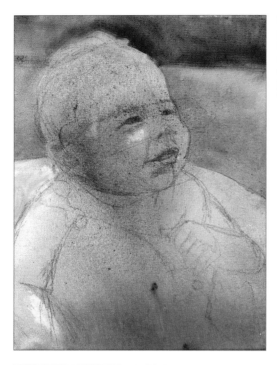

Step 2 I spritz the canvas evenly with water for a damp surface. Then, using a ratio of 1 part paint to 2 parts water, I prepare small jars of color, which I pour directly onto the canvas (see "Creating Soft Edges"). I use TRIO for the skin, quinacridone blue violet in the shadow under the chin, Prussian blue for the denim, and green gold for the grass and tree line. While the paint is drying, I use a rag to lift out lighter tones.

CREATING SOFT EDGES

When you apply color to a damp surface, it spreads naturally, but I like to manipulate the process to cover more area and achieve greater color overlap.

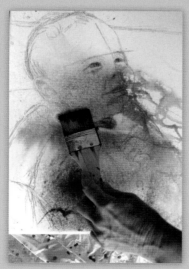

After pouring the watery washes onto the surface, I use a 2" soft-bristle brush to spread around the colors, pushing them into their appropriate shadow areas.

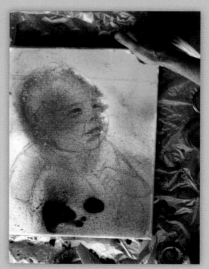

Once the colors have been spread, I tilt the canvas to let them mix and mingle, achieving soft edges and diffused areas of color.

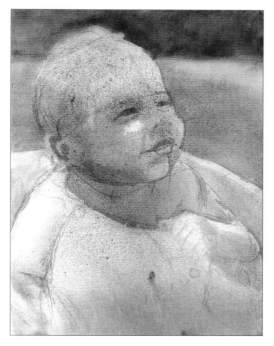

Step 3 For now, I allow the base of the skin tone established by the underpainting to stand. But before I work up to more natural tones, I want to establish the difference in value between the lighter areas of the face—which, as my focal point, I want to bring forward—and the more shadowed areas of the neck and chest. I mix a transparent glaze of TRIO and quinacridone blue violet to achieve this distinction.

Chest and Chin Shadows

TRIO + quinacridone blue violet

Chin and Neck Shadow

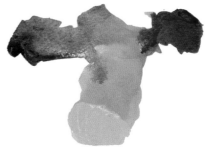

TRIO + chromium green oxide + titanium white

Cool Skin

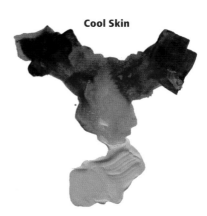

TRIO + quinacridone blue violet
+ titanium white + Prussian blue

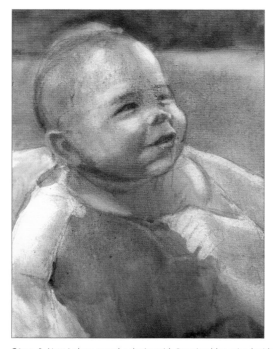

Step 4 Next I glaze over the denim with Prussian blue mixed with a little quinacridone blue violet and TRIO. I recognize that the face pigmentation is dark, so I soak a rag in rubbing alcohol to lift out color. Then I add white into the mix, gently painting over the lighter skin with a 1" soft-bristle flat brush. Around the lip, I cool the mix with a little Prussian blue. I also thinly wash quinacridone blue violet over dark facial areas, including the orbit of the eyes, the side of the face, and under the chin. Finally I mix Prussian blue with burnt umber to darken the pupils, lashes, nostrils, and inner mouth.

Step 5 I continue layering thin applications of the skin mix to achieve my desired value. I add a touch of cadmium red under the nose and on the cheeks and lips, neutralizing the shadowed lip with chromium green oxide. I make a thin mix of cadmium red, chromium green oxide, and a touch of white to create dimension where the nose turns under. I also glaze over the overalls again, using the same mix from step 4. Finally I darken the lower basket with a mix of burnt umber and Prussian blue, mixing cadmium yellow, TRIO, white, and a touch of quinacridone blue violet for lighter areas, and adding more blue violet for variation.

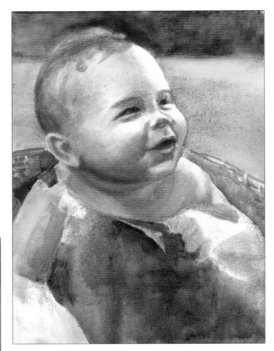

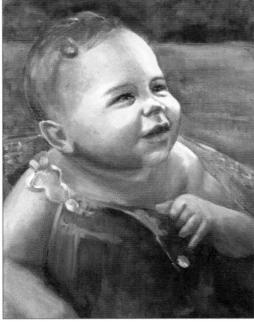

Step 6 For the eyes (see detail), I darken underneath the lashes and pupils, using burnt umber mixed with Prussian blue. For the irises, I apply a very thin layer of ultramarine blue with a touch of white in the lower portion of the eye, leaving the pupil dark. I add more white to the mix to touch in lighter specks in both irises. I add beginning layers to the hair with a combination of TRIO, quinacridone blue violet, chromium green oxide, and a touch of white. I continue building up the denim overalls. Then I mix a little burnt umber, ultramarine blue, and white to indicate the hardware.

EYE DETAIL

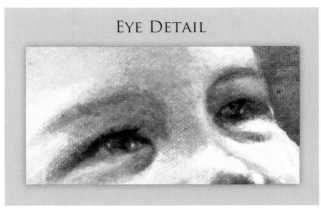

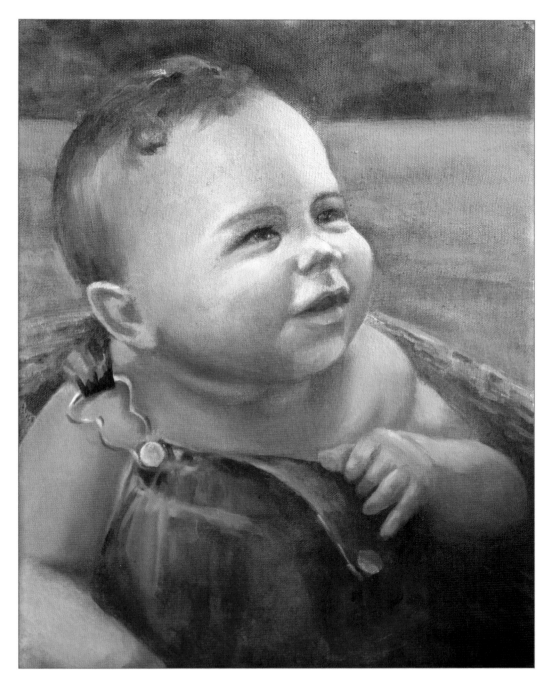

Step 7 To finish the hair, I mix a little more white and quinacridone blue violet with the TRIO and chromium green oxide, adding highlights and defining the curl. For the highlights in the overalls, I add a little white to ultramarine blue. I also place skin shadows underneath the overall clips, combining TRIO with quinacridone blue violet and a slight touch of white. For the final background touches, I cool down the farthest area of the yellow field with a mixture of brilliant yellow green and brilliant blue, which further emphasizes the subject's face while providing a spring feel to the portrait that complements the child's personality.

DEVELOPING RICH SKIN TONES

It's easy to depict realistic skin tones when developing a painting in layers. Transparent washes produce beautiful visual blends, and even more opaque applications contain hints and tones from the underlayers. The result is a dynamic skin tone that animates your subject. And it's important to develop life and vivacity when portraying a young person like this one, full of character and spirit!

Palette

cadmium red medium • dioxazine purple
Hansa yellow light • phthalo blue • Prussian blue
quinacridone violet • quinacridone blue violet
raw sienna • titanium white
transparent red iron oxide (TRIO) • ultramarine blue

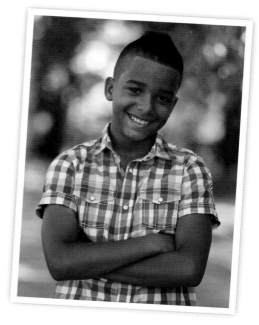

Reference photo Getting too close to a model can result in awkward pictures. Why not take photos from a comfortable distance, cropping later to frame the subject?

Step 1 I complete both a sketch and a value sketch on paper before transferring my guidelines directly to an 11" x 14" board. I retrace the outline to make it a bit darker so it will show through subsequent layers. Then I spray it with acrylic fixative to prevent the graphite from smudging and paint from beading on the surface.

Step 2 I start with the darkest values on the scale, setting up a comparison point for the colors to come later. With a 1" flat brush, I dampen the face and arms before applying a mix of dioxazine purple and raw sienna, adding more purple for deep shadows. The purple deepens the shadows while the raw sienna produces a lovely, rich skin tone.

Step 3 Still using the 1" flat brush, I block in the shirt by dropping in a loose wash of 2 parts phthalo blue and 1 part quinacridone blue violet, allowing the colors to mix and mingle on the canvas. I'm roughly blocking at this stage, but I do try to keep the wash thinner in areas that will be lighter, while pushing a little more color into darker regions.

Step 4 For the dark hair, facial creases, and shirt shadows, I use less water as I mix 2 parts Prussian blue and 1 part TRIO, applying with a damp #8 filbert. I also lightly brush on a mix of TRIO and quinacridone violet with a touch of Prussian blue for luminous orange skin tones. For the background, I wet the board and then drop in a loosely mixed thin wash of 3 parts Hansa yellow light and 1 part phthalo blue.

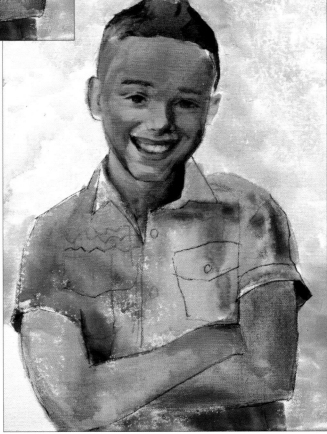

Step 5 I'm building up the skin in layers to create a varied, lifelike tone. Next I use a thin orange mix of 3 parts TRIO to 1 part quinacridone blue violet to punch up warm tones in the shadows, around the cheek and forehead, and on the arms. I also indicate reflected light on the left side of the face with a thin layer of dioxazine purple mixed with white. I lighten up the background by applying white mixed with Hansa yellow light.

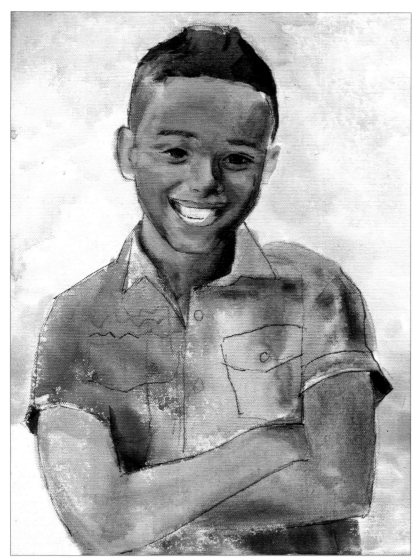

Step 6 I mix 3 parts white with 1 part TRIO and 2 parts dioxazine purple for a cooler layer to establish the lightest skin tones and balance out the underpainting. I add a little light brown (white, TRIO, and Prussian blue) to the lower left corners of the irises. I also layer a thin application of white over the whites of the eyes, which still appear a little gray because of shadows. To lighten the teeth, I gray down white with a little Prussian blue and TRIO, making the edges near the mouth a slightly darker value.

MOUTH DETAIL

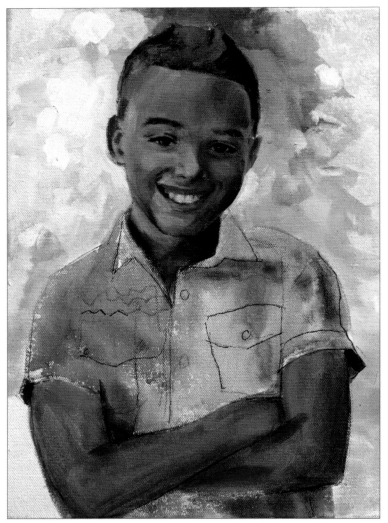

Step 7 Next I use a mix of dioxazine purple, TRIO, and Prussian blue to darken the jaw and facial shadows. I switch to a stiff dry brush to round the cheeks with a white, TRIO, and raw sienna mix, also giving the ear form with a dioxazine purple, TRIO, and white mix. I apply the arms' shadows using TRIO mixed with Prussian blue and quinacridone blue violet. I use a base mix of 2 parts quinacridone blue violet and 1 part TRIO on the lips, making the mouth's corners darker. Then, to frame the head, I make circular strokes with a thicker mix of phthalo blue, Hansa yellow light, and white in the background.

EYE DETAIL

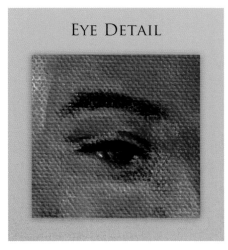

EAR DETAIL

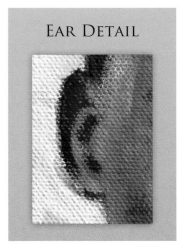

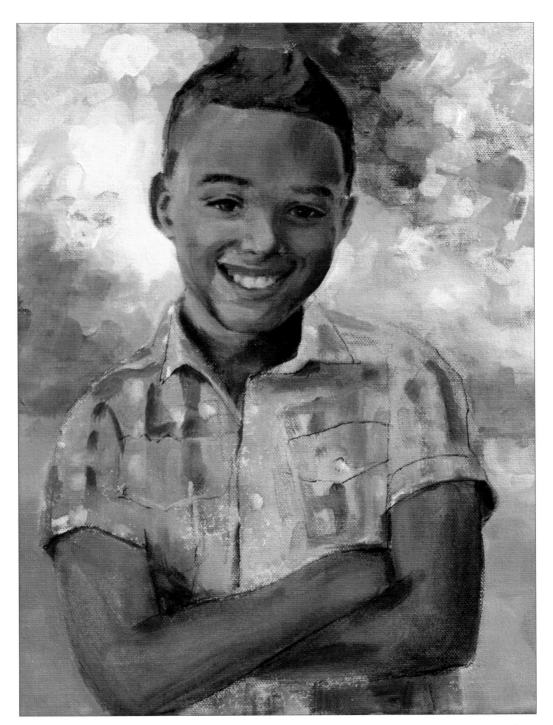

Step 8 I scumble in leaves, warming the green with TRIO. I also mix phthalo blue, white, and a touch of quinacridone blue violet for the shirt, alternating dark, light, and white. The buttons are white with a touch of ultramarine blue. For sunlight, I brush phthalo blue with a touch of white on the hair, adding cadmium red medium behind the ear and Prussian blue around it. The irises each get a touch of white mixed with ultramarine blue. To finish, I layer more of the same skin tone mixes where I see the need.

TELLING A STORY

A portrait is a likeness of a person—not just the way they look, but who they are. Including something your model loves, whether a favorite color or outfit or even a favorite pet, can make the portrait all the more personal. Find out what your subject is passionate about, and try to include some element of that in your painting. For this portrait, I had the opportunity to paint an avid rider. Her riding gear, blue ribbon, and horse were natural complements!

Palette
brilliant green • cadmium red medium
cadmium yellow medium • dioxazine purple • green oxide
Hansa yellow light • phthalo blue • Prussian blue
quinacridone magenta • quinacridone blue violet
raw umber • titanium white
transparent red iron oxide (TRIO) • ultramarine blue

WORKING WET-INTO-WET

I enjoy using the wet-into-wet technique because of the somewhat unpredictable results. The variation can add a lot of life and interest to a painting!

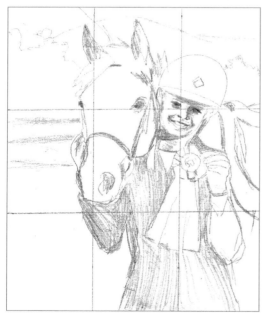

Step 1 I use the grid method to transfer my image to a 16" x 20" canvas. Although I don't fill in all the values, I do indicate the darker ones so I'll have a guide as I begin layering.

When covering a wide area wet-into-wet, I recommend taking the canvas outside or laying down a large sheet of plastic to avoid a mess. I spray the canvas with water. Then I pour each watery wash directly onto the surface in the appropriate area.

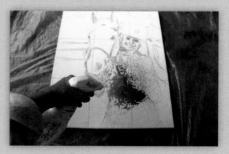

Spraying water on top of an existing wash can re-wet an area where you want two neighboring colors to blend and transition. It also can cause the wash to spread if the color is too thick or you'd like to cover a broader area than your pour allowed.

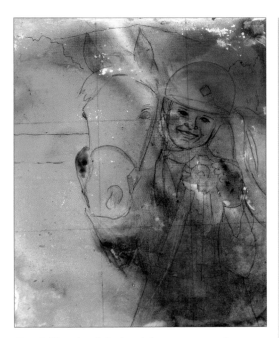

Step 2 My underpainting loosely lays out my core colors. Painting wet-into-wet, I use Prussian blue with phthalo blue for the base, dioxazine purple for the deep values, and TRIO with quinacridone magenta around the face. (See "Working Wet-into-Wet" on page 38.) When the canvas dries, I retrace my sketch in permanent black ink.

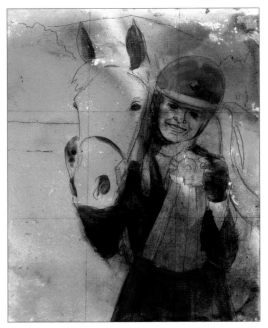

SPREADING GESSO

A thin coat of gesso will tone down the color underneath. It also provides a work surface that will allow me to easily lift out paint with a damp cloth in future steps.

To apply gesso to a canvas, I like to use an old gift card or credit card. I use extra heavy gloss gel for this purpose, spreading it thinly over the whole canvas.

As I spread the gesso, I try to make it as smooth as possible; although sometimes having a little extra texture makes the painting more exciting.

Note how the color begins to show through as the gesso dries. It's important to let the gesso dry completely before resuming painting. When in a hurry, I use a hair dryer.

Step 3 For dark values, I mix a thin wash of Prussian blue, quinacridone blue violet, and raw umber. The bright blue is a bit too vibrant, so I tone it down with gesso. (See "Spreading Gesso" above.) Then I define my light values using a #8 filbert brush and a mix of white with quinacridone blue violet and cadmium red for the sky, also blocking in trees with a 1" flat brush and a mix of phthalo blue, brilliant green, and white.

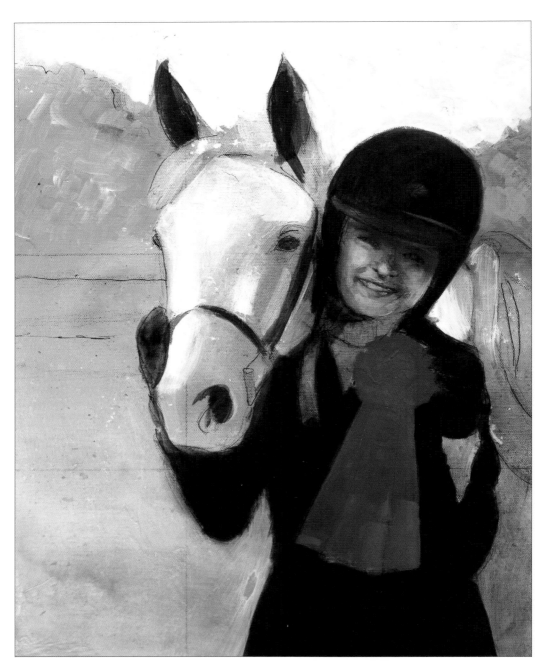

Step 4 I use a little white to define the horse's face. I build the girl's face in layers, starting with a mix of cadmium red medium, cadmium yellow medium, and white. For darker parts like the nostrils, I mix raw umber with quinacridone blue violet. I use lighter values of the same mixes next, also going back over the shadows with a mix of dioxazine purple, raw umber, cadmium red medium, and white. For the shadows under the hat, I mix raw umber with purple and cadmium red medium. I darken the lash lines, irises, and pupils with raw umber mixed with Prussian blue, using a touch of ultramarine blue for iris color. The horse's ears and nose are a thick raw umber, dioxazine purple, and white mix. I also fill in the ribbon, mixing ultramarine blue, quinacridone blue violet, and a touch of white.

GRASS DETAIL

LIP DETAIL

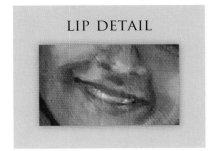

Step 5 I continue layering lighter values of the same mixes on the face. For the lips, I brush on cadmium red medium, quinacridone blue violet, and raw umber, with a magenta and white highlight. I use thin layers of ultramarine blue and white to fill the shirt. I begin the short grass strokes with a mix of white, phthalo blue, and brilliant green at back and move forward with green oxide, brilliant green, and less white. For the path, I use raw umber, cadmium red medium, and titanium white, with a darker mix of raw umber, ultramarine blue, and titanium white for the shadows.

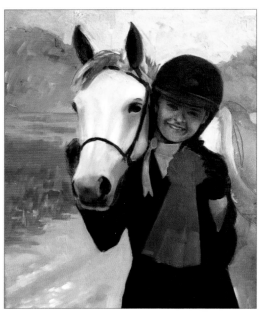

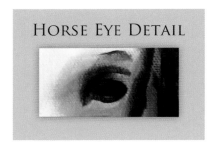

Step 6 I turn my attention to the horse, using a stiffer, drier brush to block in the face with a mix of titanium white and raw umber with a touch of cadmium red medium. I scumble a second layer on the lightest areas. For the grays around the face, I mix raw umber, Prussian blue, and white. The darker parts are a mix of raw umber and Prussian blue. I fill the bridle with a mix of Prussian blue, raw umber, and a touch of TRIO.

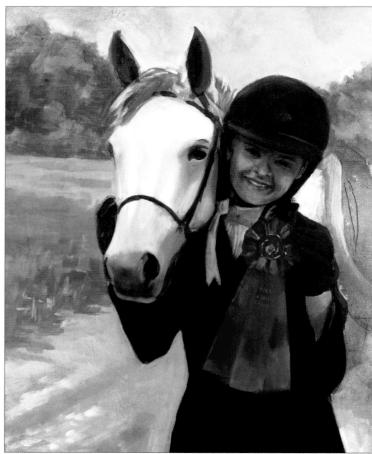

Step 7 I return to the shirt to add thin ultramarine blue and white pinstripes. Next I mix touches of quinacridone blue violet and white into ultramarine blue to add shiny reflections to the ribbon. I mix raw umber with cadmium yellow medium and white to touch in indications of gold trim with a fine-point brush. For the lightest areas of the hat and gloves, I brush on the Prussian blue, quinacridone blue violet, and raw umber mix with a little white. Then I tone down the trees with a mix of phthalo blue, green oxide, and white.

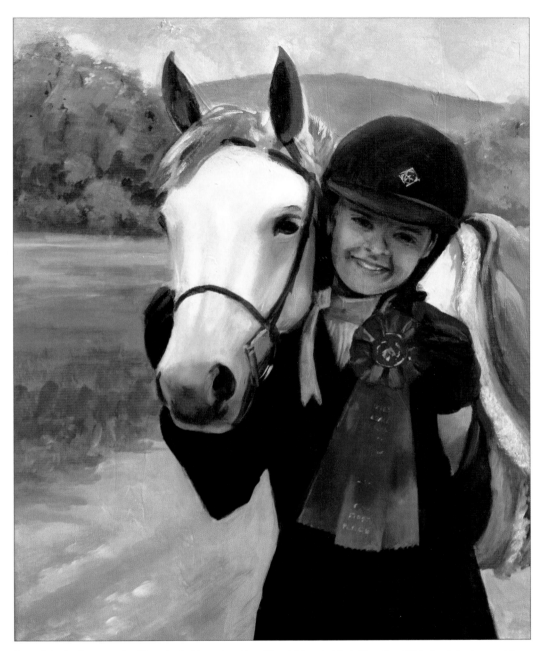

Step 8 I paint the mountain with a mix of white, quinacridone blue violet, and phthalo blue. Then I fill in the darkest areas of the saddle with a mix of TRIO, raw umber, and ultramarine blue, using a bit more TRIO for the browns. The saddle pad and horse's shoulders both repeat the color combinations used on the horse's face. For the topmost part of the saddle, I mix cadmium red medium, quinacridone blue violet, raw umber, and white. To finish, I add more white to the hat highlight mix to paint the diamond medallion on the hat and the shiny areas of the bit.

MAKING A MODERN PORTRAIT

When your subject is young and contemporary, her portrait should match. I was sure to replicate this model's nose ring and purplish hair tint. I also deliberately made the backdrop more modern, giving the trees a bluish tone for effect.

Palette

alizarin crimson • cadmium yellow medium
Hansa yellow light • phthalo blue • Prussian blue
quinacridone magenta • quinacridone purple
quinacridone red • quinacridone violet • quinacridone
blue violet • raw sienna • raw umber • titanium white
transparent red iron oxide (TRIO) • yellow ochre

Step 1 I crop my photo to focus on the young lady's features before using the grid method to transfer the image to a hard canvas board with a dark pencil. I trace over the sketch with black ink, noting the areas where the shading is lightest. I mist the whole board with water before applying any paint.

Step 2 First I drop a mix of raw sienna and quinacridone purple on the face. I mix phthalo blue, quinacridone magenta, and Hansa yellow light for hair. Then I apply yellow ochre and magenta to the skin. Next I mix magenta and yellow ochre for the shirt. The trees are Hansa yellow light and phthalo blue; the sky, phthalo blue and quinacridone violet; the land, yellow ochre and quinacridone violet.

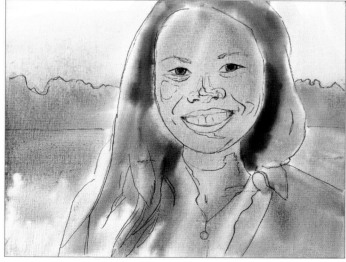

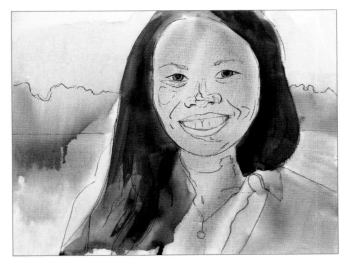

Step 3 I begin on the darker values, starting with the hair around the face. I use a mix of phthalo blue, magenta, and Hansa yellow light that varies in value according to its placement. Where the hair is browner, I add a touch of TRIO for warmth.

Step 4 Using yellow ochre mixed with quinacridone red, I darken the neck, smile lines, and sides of the face. I also apply a more opaque mix of raw umber and magenta on the right side of the face and around the smile lines, using more magenta at the top of the forehead and on the lower part of the cheek. I also add a bit of violet to deepen shadows under the chin.

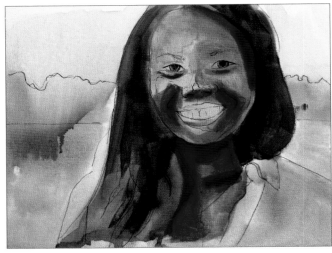

Step 5 With a 1" flat brush, I darken areas under the chin and around the cheek with a more opaque mix of TRIO, quinacridone violet, alizarin crimson, white, and a touch of phthalo blue. I push the shadows here to help give the face a rounded appearance.

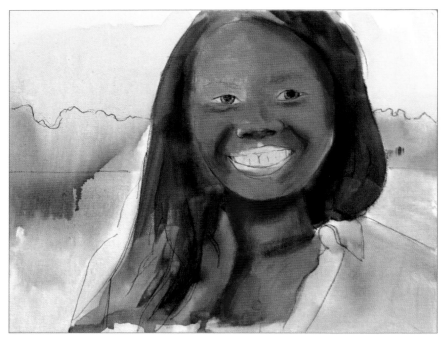

Step 6 Now I want to apply midtones with a bit more yellow to establish skin tone. I mix more yellow ochre with quinacridone purple, alizarin crimson, TRIO, and white.

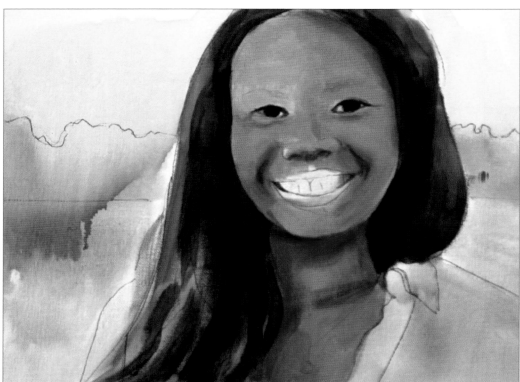

Step 7 For the darkest darks in the hair, I mix Prussian blue with quinacridone blue violet and TRIO. I use the same combination for the eyes but with more TRIO to warm them. I add quinacridone violet to the mix for the more purple-toned portions of the hair and for the smile lines.

Step 8 Now I want to establish the true color of the skin, which is a mixture of yellow ochre, alizarin crimson, and white. I use a lighter value of this color to start, applying it to the lightest parts of the skin with light scumbling. Then I move into the core midtones before transitioning into shadow, using less and less white.

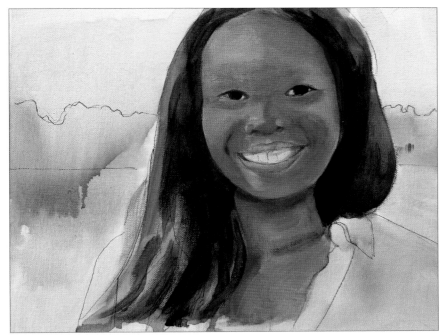

Step 9 I'm still using the mixture from step 8, but now with more alizarin crimson and white for pink tones. The lighter paint pulls the rounded areas of the cheeks, chin, and forehead forward. I add a little dark tone in the creases with the shadow colors from step 8. Then I scumble a mix of alizarin crimson and white on the lips. I paint the teeth with titanium white mixed with touches of TRIO, Prussian blue, and yellow ochre.

Step 10 I warm the irises with a mix of TRIO and raw umber, touching on pure white for highlights. In the mouth's corners, I mix Prussian blue with TRIO and quinacridone violet. I apply white mixed into alizarin crimson for the bright part of the lips.

Step 11 I mix a light value of white, quinacridone violet, and phthalo blue for the sky and scumble a cool base of phthalo blue with a touch of Hansa yellow light for the greenery. Then I use a slightly damp brush to dab on a warmer layer of cadmium yellow medium, phthalo blue, and a touch of white. In the foreground, I mix yellow ochre, magenta, and a little white, darkening the mix with a touch of raw umber as I move down the canvas. I add additional layers to the shirt to build up the fabric, using quinacridone magenta with yellow ochre and titanium white.

Step 12 Now I turn to the final details. For the necklace, I indicate the shadows by outlining it with a touch of raw umber. Then I lightly brush on a thin layer of white in the light areas to create a reflective quality. For the nose ring, I paint a small crescent shape with raw umber, curving under the nostril. For reflection, I brush a thin layer of white over the edge of the ring. I finish painting the shirt, adding a lot of white to the original shirt mix to keep the overall value light. I add pure titanium white highlights.

USING OPAQUE COLOR

Transparent layers of acrylic paint mimic the soft effect of watercolor, which I enjoy using for portraits. But for this strong, masculine subject, I decided to work with thicker, more opaque paints, layering in a way more reminiscent of oil painting. With this approach, the underpainting has less influence on the finished piece.

Step 1 I paint the canvas with a loose mix of raw sienna and raw umber. Then I use raw umber and a #8 brush to mark the head's top, bottom, and width. I indicate the brow and bottom of the nose. Then I mark the nose width, using it to place the eyes. I mark the mouth in relation to the nose and eyes.

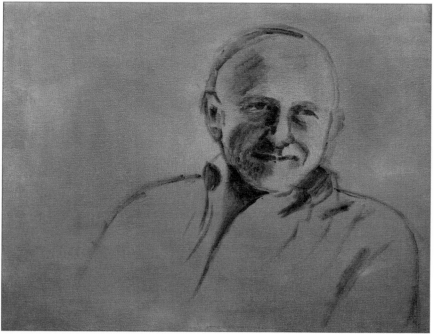

Step 2 I finish the face using my marks as guidelines. I turn my attention to outlining his shirt. Then, still using the burnt umber, I switch to a flat, ¾" soft-bristle paintbrush to lightly note the locations of the darkest darks and middle values.

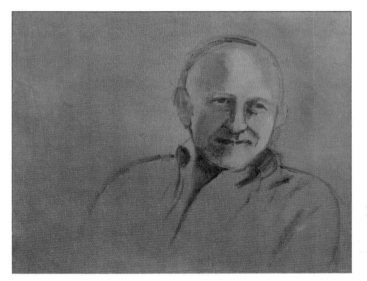

alizarin crimson + raw sienna
+ titanium white + yellow iron oxide

Step 3 With the same brush, I apply a mix of alizarin crimson, raw sienna, and white to the face. I use a little more alizarin crimson on the cheeks, nose, and forehead. Then I gray the mix with touches of raw umber and manganese blue for the midtones: the left cheek, forehead, and ear, and the crease in his right cheek.

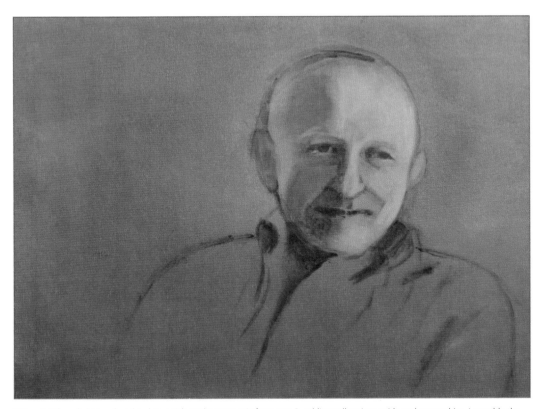

Step 4 Where light touches the skin, I pick up the same mix from step 3, adding yellow iron oxide and more white. I scumble the color where I want to achieve yellow reflections on the skin, lightly brushing the paint in a circular motion.

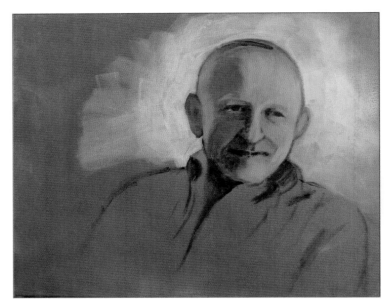

Step 5 I add a bit of background so I have a comparison for the skin values, using white with touches of ultramarine blue, raw umber, and yellow iron oxide. With the background in place, I see I need to lighten the skin, so I mix white with touches of cadmium red medium and prism violet for a pinker tone in the uppermost skin around the head.

Background

titanium white + ultramarine blue
+ raw umber + yellow iron oxide

Step 6 To push the left of his cheek and head into shadow, I mix a greenish hue with alizarin crimson, raw umber, white, and a touch of manganese blue. I return to the background, painting wet-into-wet with a wide, flat brush loaded with white mixed with touches of cadmium red light and violet to make crosshatched strokes that blend.

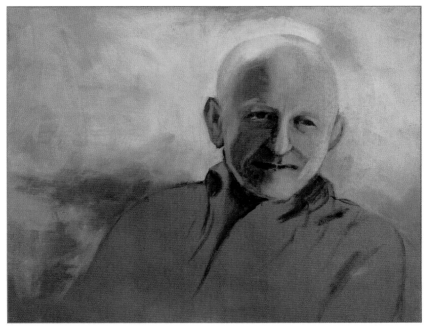

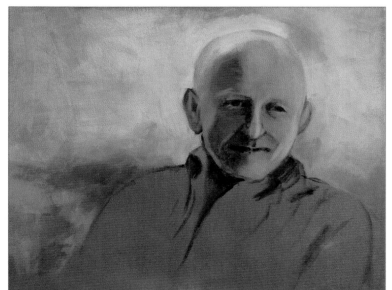

Step 7 For the lightest reflections on the skin, I add touches of quinacridone purple and cadmium red medium to white. I drybrush this mixture onto the canvas with a stiff bristle brush, scumbling the paint onto the brightest areas of his face and head, blending to avoid hard lines.

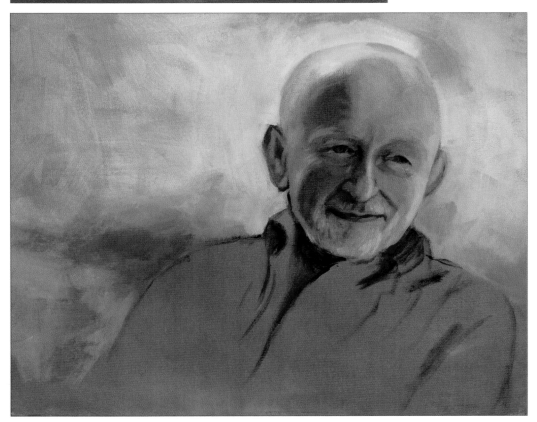

Step 8 I line the wrinkles using the light skin tone from step 7. I touch alizarin crimson in the lip corners. Then, for the reflection, I mix alizarin crimson, raw sienna, and a touch of white. I add more white for lip highlights. For the beard, I make short, fine downward strokes with a small filbert brush, applying skin tones under the chin and lip and then adding a gray mix of white, ultramarine blue, and burnt umber.

EYE DETAIL

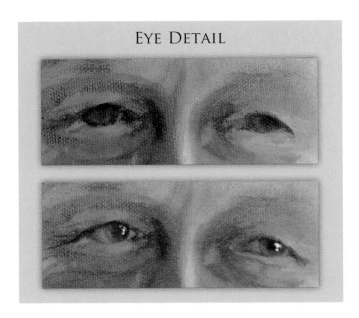

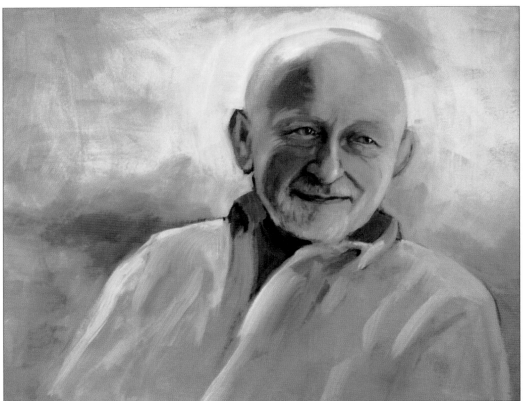

Step 9 I block in the shirt, scumbling white mixed with ultramarine and manganese blues with light streaks of red, green, and yellow. I darken the eyes with a dark mix of raw umber, ultramarine blue, and a touch of alizarin crimson. For the irises, I apply a mix of manganese blue, raw umber, and white with a fine-tipped brush. The "whites" of the eyes are grayed, but the reflection spots are pure white.

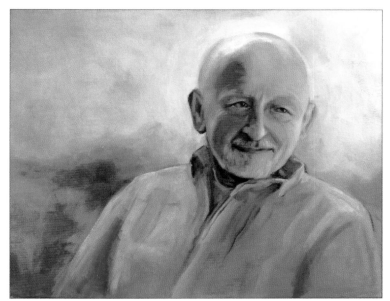

Step 10 I take a step back to view my progress. I decide to further refine the wrinkles, returning with the light skin tone color from step 7. I also touch up a few other details on the face, adding a touch of red to the corners of the eyes and adding some reflection to the inside corners of his inner eyelids.

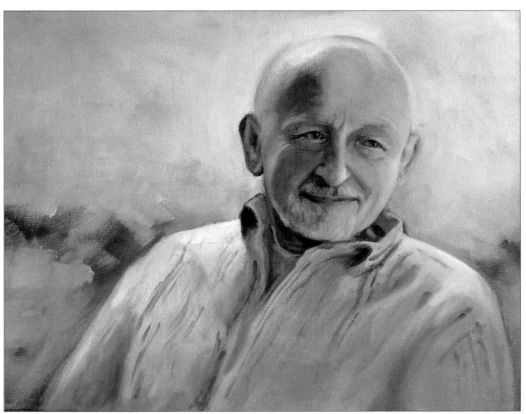

Step 11 To finish, I return to the shirt, building up the layers by scumbling on additional applications of the colors from step 9, this time giving it a bit more detail. I also touch up the neck with the shadowed mix of alizarin crimson, raw umber, raw sienna, and a little white.

WORKING WITH MIXED MEDIA

Texture adds interest to a painting, and I enjoy many different ways of achieving this effect. For this portrait, I wanted to combine acrylic paint with a collage of specialty papers for a unique visual that is not only beautiful but also imbued with meaning. You may choose to simply paint on a regular support without papers.

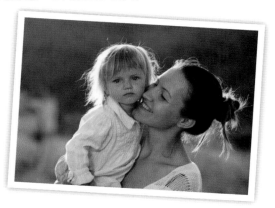

Palette

alizarin crimson • brilliant yellow green
cadmium red light • cadmium red medium
green oxide • Hansa yellow light • Indian yellow
phthalo blue • Prussian blue • quinacridone purple
quinacridone violet • raw umber • titanium white
transparent red iron oxide (TRIO) • ultramarine blue

Step 1 I begin by blocking in the composition on a canvas board—a surface that won't buckle with the application of media. After wetting the canvas, I apply a loose wash of phthalo blue mixed with quinacridone violet to the upper portion with a 2" flat brush. At the bottom, I apply Indian yellow. I gently tilt the board at the top, and then in all directions, allowing the colors to mix for a soft effect.

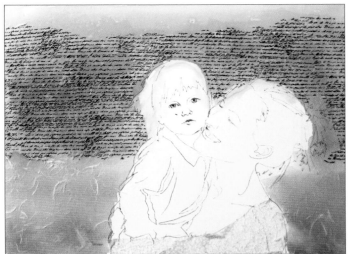

Step 2 While my initial washes are drying, I gather specialty printed paper, rice paper, and gloss gel medium. I layer the papers, applying a collage that will give this portrait a distinct look. (See "Applying Mixed Media" on page 57.)

Applying Mixed Media

Acrylic paints dry so quickly that creating textures is as simple as thickly layering paints or using implements to make impressions. I also enjoy creating texture through the addition of materials, including paper, for a unique effect.

Step 1 I'll be using rice paper to add an interesting, grassy texture. Paper also can help tell a story. For instance, I've chosen paper with written words that have meaning for the portrait's subject, giving the painting greater emotional impact.

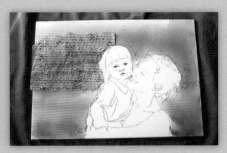

Step 2 I start by lining up the background paper on the canvas, gently tearing it to frame the outline of the woman and child.

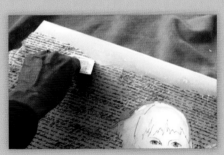

Step 3 Next I place a thin layer of gel on the canvas to adhere the paper. After applying the paper, I use an old gift card to spread a thin layer of gel over the paper too, smoothing it into place.

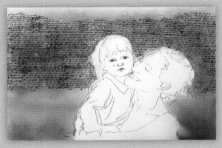

Step 4 Once the background paper is in place, I allow it to dry completely before moving on to the next step.

Step 5 I repeat the same technique with rice paper, with one small change: I apply gel to the canvas and adhere the paper before tearing it.

Step 6 I also apply rice paper to the woman's blouse. When finished, I paint gloss medium over the entire canvas with 2" flat brush. I allow this to dry until it is no longer tacky.

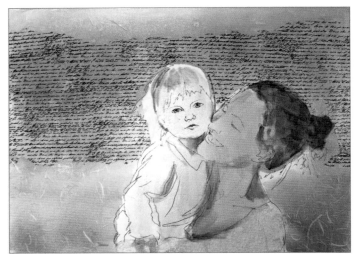

Step 3 I'm ready to apply paint at this stage, starting with the darkest shadows, which I define with raw umber. For the basic skin tone, I mix quinacridone purple, cadmium red light, and raw umber, layering a very thin wash over the woman's neck and face and over the child's face and dress with a soft-bristled, slightly wet 1" flat brush.

Step 4 Now I warm up the skin with a thicker, more opaque mixture of white, cadmium red light, and quinacridone purple, applied to the child's face and the woman's neck and forehead. I also mix cadmium red light, quinacridone purple, green oxide, and white for the midtones of the woman's face. The green tone will disappear as I continue to layer, working from dark to light.

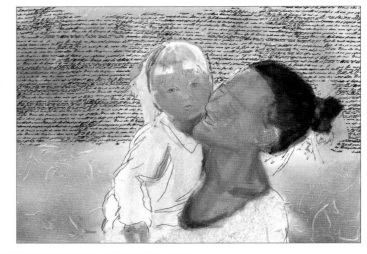

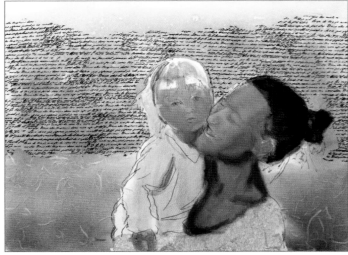

Step 5 I revisit the woman's cheeks, forehead, and neck with a damp brush and a thin layer of cadmium red light with a touch of quinacridone violet. I also lightly apply a mix of quinacridone purple, cadmium red light, ultramarine blue, and white to this same area.

Step 6 I scumble over dark areas with green oxide, quinacridone purple, and TRIO. I also scumble purple, cadmium red light, ultramarine blue, and white on the nose, cheeks, chin, neck, and baby. I apply this mix to the woman's hair, neck, and smile lines with a damp brush. Then I drybrush to soften harsh lines with a mix of raw umber, purple, and TRIO.

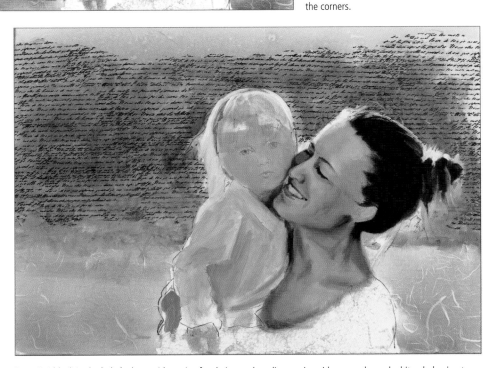

Step 7 I apply full-strength raw umber, quinacridone purple, and ultramarine blue to the woman's hair. Then I mix cadmium red medium, purple, and raw umber for the lips. For the brows, lashes, and mouth's corners, I mix raw umber, a little ultramarine blue, and purple. I mix raw umber, white, and ultramarine blue for the teeth, darkening at the corners.

Step 8 I block in the baby's dress with a mix of cadmium red medium, quinacridone purple, and white, darkening to define the fold and shadow areas. For the backlit hair, I use Hansa yellow light mixed with white for the ends; the wispy hairs are mostly white mixed with small quantities of cadmium red medium and purple.

CHILD'S FEATURES

There are two faces in this portrait, but the child's face is the focal point, so I spend more time on this area of the painting.

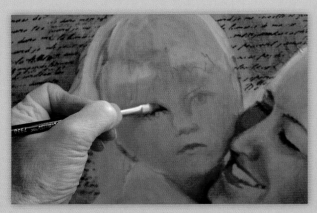

Step 1 I start with a thin wash of alizarin crimson, green oxide, and cadmium red light, which I use to darken the eye sockets, sides of the nose, and upper lip. I place the darkest values of the eyes and lashes with a mix of raw umber and Prussian blue.

Step 2 Note that when I paint the darkest values of the eyes, I fill in the entire pupil and iris area. I'll paint over this later to add iris color and highlights, but developing this area from dark to light provides both depth and emotion in the eyes.

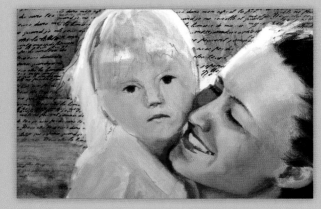

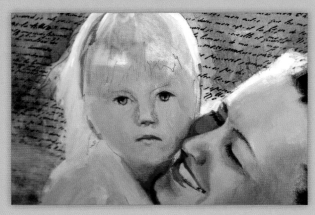

Step 3 Next I mix ultramarine blue with a touch of raw umber and white, touching this color into the brightest area of the iris. I leave a dark outline around the colored part of the iris, and the pupil also remains intact with the underlying darker value.

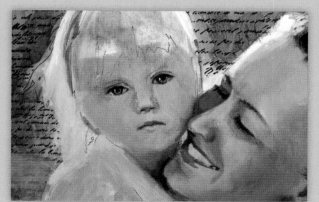

Step 4 With the dark value, I add shadow under the lashes. I mix alizarin crimson, cadmium red light, and raw umber for the eyes' inside corners. The "whites" are raw umber, white, and a touch of ultramarine blue. For highlights, I touch on pure white.

Step 5 For the lips, I apply thin layers of a mix of alizarin crimson, cadmium red light, and quinacridone purple, building up the value and darkening the lips at the corners of the mouth while leaving the lightest area of the bottom lip without pigment.

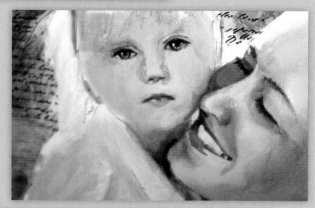

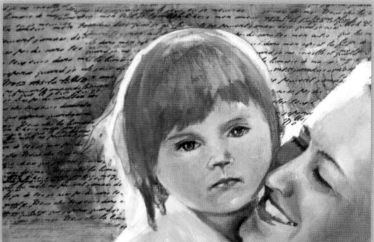

Step 6 For the cool tones of the cheeks, chin, and forehead, I build up thin layers of a quinacridone purple, cadmium red medium, and white mix, adding more white for lighter layers. For hair, I mix raw umber, purple, and green oxide, with more white around the face.

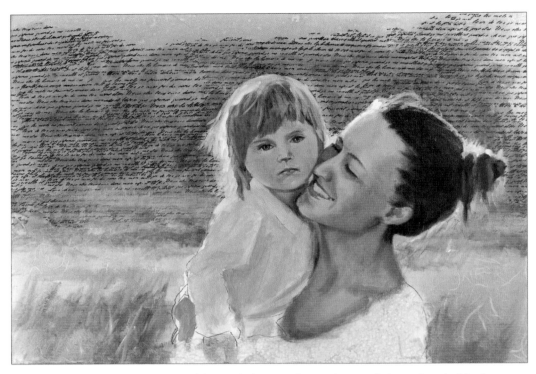

Step 9 For the highlights in the baby's hair, I lighten up the hair mix with more white to stroke in strands on the right; the remaining highlighted wisps are a light mix of quinacridone purple, cadmium red medium, white, and a touch of Indian yellow. I revisit the baby's dress, layering with the same colors from step 8. I also paint the background, working from background to foreground (see details below).

BACKGROUND DETAIL

Making short up-and-down strokes with a flat 1" soft bristle brush, I apply phthalo blue, quinacridone purple, green oxide, white, and Hansa yellow light for a cooler cast. As I reach midground, I switch to Indian yellow, brilliant yellow green, white, and green oxide.

FOREGROUND DETAIL

For the foreground, I thicken the paint and warm it up with a mix of green oxide, Indian yellow, and a touch of quinacridone purple, stroking in thin blades of grass for texture.

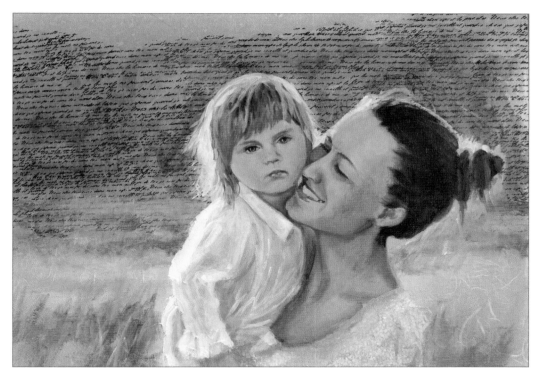

Step 10 All that's left are the final details. I add a thin, transparent wash to the woman's blouse, mixing white, quinacridone purple, and ultramarine blue. I also form the baby's hand with the skin tone mix of cadmium red medium, quinacridone purple, and white.

CLOSING THOUGHTS

I did not start out able to paint overnight. Just like any writer, musician, painter, etc., I had to learn certain steps to move on to the next level. I learned much of what I know in graphic arts courses in college, but my biggest steps were achieved from watching other artists, reading books and articles, and practicing many times over. I owe a lot of gratitude to my mother, Elizabeth Miller, and my teacher Vera Dickerson, who were very patient in teaching me so many of the skills that I so enjoy to this day. I also owe a lot of gratitude to my family for being so patient with this aspiring artist.

I encourage you to keep on keeping on...and always strive to continue learning and enjoying the process. My hope is that you will take some of these tools and tips and use them as catalysts to move you to your next level of portrait painting. Most importantly, remember to have fun and be excited at each step along the way, whether it is a tiny light bulb going off or a blaring bullhorn. We were born as creative beings. Express! Embrace! Enjoy!

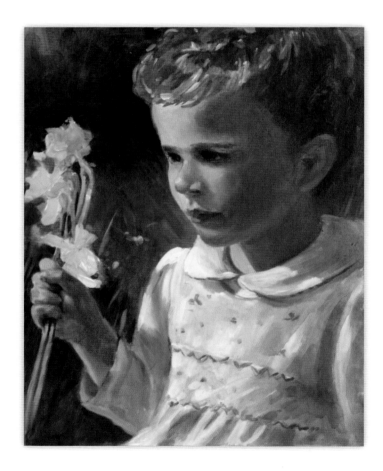